H50 277 387 7

Hertfordshire
COUNTY COUNCIL
Community Information

9 NOV 2000

2 1 DEC 2000

1 MAY 2002

2 1 FEB 2004

L32a

OVS
730.
92
CAR
CAR

Anthony Caro

Sculpture towards Architecture

Anthony Caro
Sculpture towards Architecture

PAUL MOORHOUSE

Tate Gallery

Exhibition sponsored by KPMG Management Consulting

KPMG Management Consulting

The sponsorship of *Anthony Caro: Sculpture towards Architecture* by KPMG
Management Consulting has been recognised by an award under the
Government's Business Sponsorship Incentive Scheme, which is
administered by the Association for Business Sponsorship of the Arts.

Cover: Interior view of 'Octagon Tower –
Tower of Discovery' 1991

ISBN 1 85437 085 5

Published by order of the Trustees 1991
for the exhibition of 16 October 1991 – 26 January 1992
© copyright 1991 The Tate Gallery All rights reserved
Published by Tate Gallery Publications, Millbank, London SW1P 4RG
Designed by Caroline Johnston
Typeset by Servis Filmsetting Ltd, Manchester in Monophoto Photina
Printed in Great Britain by Balding + Mansell plc, Wisbech,
Cambridgeshire on Parilux matt white 150gsm

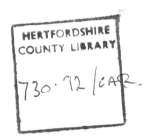

Contents

Foreword

For nearly thirty years Anthony Caro's achievements as a sculptor have commanded international appreciation and admiration. However, an important element in the development of his sculpture, which has nevertheless received little attention from commentators, has been the inspiration he has drawn from architecture.

During the last decade the architectonic nature of Caro's work has become more overt. The Trustees are therefore delighted that he should have responded so positively to the invitation to show new work in the recently refurbished Duveen sculpture galleries. He has elected to show four major works of monumental scale which are each the product of his engagement with the relationship between sculpture and architecture. One of these works, 'Octagon Tower – Tower of Discovery', was commissioned specially for the exhibition and responds directly to the central space of the sculpture galleries, the Sackler Octagon.

The catalogue essay has been written by Paul Moorhouse, Assistant Keeper in the Modern Collection, who worked closely with the artist. We would like to extend our thanks to Anthony Caro for the time and help he gave in all aspects of the planning of this exhibition. We should also like to thank Ian Barker of Annely Juda Fine Art and Pat Cunningham and Sue Brown, Anthony Caro's assistants, for their enthusiastic support. We would like to extend our special gratitude to Sheila Girling. The exhibition has been sponsored by KPMG Management Consulting as part of their sponsorship programme, 'Future Positive', designed to promote the commissioning of new art. We are grateful to the company, and in particular to Bob Simm, Dawn Austwick and Laurence Newman, for a sponsorship which sets new levels in its imagination and generosity. Sponsorship which supports the creation of new work is still relatively rare, though we hope that the success of this project, allowing an established artist to break into new territory, will encourage others. As with so many of our activities involving sculpture, we are grateful for the additional support which we have received from the Henry Moore Foundation.

Nicholas Serota
Director

Sponsor's Foreword

In February 1991 KPMG Management Consulting announced details of 'Future Positive – A partnership for new work'. Future Positive is a three year sponsorship programme that has been devised and developed with the Tate Gallery, the Royal National Theatre and the English National Opera. The programme centres around the twin themes of excellence and innovation; qualities that are vital to us and to our artistic partners as we go about our daily business.

It is most fitting, given these twin themes, that the first fruits of our programme should be both a new work and a celebration of the existing body of work by so distinguished a British sculptor as Anthony Caro. Our programme is designed to explore new approaches by established artists as well as the discovery of young and fresh talent.

We hope that our, albeit small, contribution to the creation of a contemporary voice in the arts in Britain, will help to stimulate debate about the value of innovation and of risk both in the arts and in life generally. We would also like it to be read as a statement of confidence in the contemporary arts and the contemporary world.

Bob Simm
Senior Partner
KPMG Management Consulting

'A Sense of Architecture':
The Sculpture of Anthony Caro

> To use the elements that can strike our senses, to gratify our visual desires and
> so to arrange them that the sight of them clearly affects us by the fineness or
> the crudity, the tumult or the serenity.
>
> Le Corbusier[1]

In 1985 Anthony Caro visited Greece for the first time. Until then he had resisted
the sense of duty which implied that, in order to complete his education as a
sculptor, it was necessary to steep himself in the achievements of classical art. It
seemed to him that the momentum of his artistic development was always
sustained by 'refusing to go along with what was expected'.[2] Nevertheless, Caro
was profoundly affected by the sculpture and architecture which he encountered
at Olympia and the Acropolis. Indeed, he has observed that as a result of this
experience, 'I have become more and more conscious of the relation of sculpture
to architecture and the fusion of both, something felt right from the start'.
Elsewhere, he has stated that 'I have had an interest in the architectonic aspect of
my sculpture for a long time'. These statements are important, not only for the
light they shed on the recent sculpture in the present exhibition, but also because
they identify an aspect of his earlier work which paves the way for these later
developments. An appreciation of Caro's engagement with the relation of sculp-
ture and architecture is thus crucial to an understanding of his oeuvre as a
whole. This essay will therefore focus on the development in Caro's sculpture of
what he has described as 'a sense of architecture'.

The seeds of this development are apparent in the figurative sculpture which
Caro made between 1954 and 1959. Earlier in that decade Caro had spent two
years as an assistant to Henry Moore in his Hertfordshire studio. However there
is no trace of Moore's influence in the figures which Caro began to make after his
return to London in 1953. Reacting against the smooth surfaces of Moore's
carved forms Caro investigated the expressive potential of clay, modelled freely
and subject to the intervention of chance. Caro would drop and hit soft clay so
that the resulting shapes suggested forms which could then be developed. The
figures which emerged from Caro's imagination were massive and ungainly.
Their surfaces impressed with pebbles, fragments of cast objects and other found
materials, they seem burdened with their own material existence.

In these works Caro sought to infuse dumb matter with a sense of inner life and sensation. In 'Man Taking Off his Shirt', 1955–6 (fig.1), for example, the awkwardness of the limbs and the huge bulk of the torso compressing the legs impart a sense of tension. We project an idea of felt experience into the clay. The expressionistic element in these works is not, however, used to convey angst or heightened emotion. Despite their pitted surfaces and formal distortions the unremarkable, almost banal actions performed by these figures – 'Man Holding his Foot', 'Woman Arranging her Hair', 'Woman Waking Up' – locate them firmly within the realm of the ordinary and everyday. Caro's emphasis on texture and form expresses experience of a universal and less extreme kind. Moreover, his treatment of mass, form and space may already be seen to manifest concerns of an architectonic nature.

Caro's 1974 essay 'Some Thoughts after Visiting Florence'[3] includes the following observations:

> [Donatello's] sculpture has quiet, still resting places for the spectator. In . . . the beardless St John the Baptist, the superb Amor-Atys, or the great David, it is more as if the sculpture is considered as a building with front, back and side elevations. The forms inflect against the datum of flatness. In the David for instance, the buttocks jut out like a window ledge . . .[4]

According to this analysis the figure is judged architectonically. That is, in terms of its capacity to animate, articulate and enclose the surrounding space; define planes, elevations and areas of activity and rest for the spectator; and establish a satisfying network of internal relations. These ideas are germane to Caro's own sculpture during the 1950s.

In 'Man Taking Off his Shirt' the figure sits squarely on the ground establishing four principal viewpoints: front, back and two side elevations. The thrust and direction of the limbs are judged in relation to these solid planes. They jut out into the surrounding space, creating a complex interaction of angles, mass, line and space. Caro observed of Donatello's freestanding sculptures that they are 'not "naturalistic", in that they do not aim to conquer the world in the way that natural growing things do. They ask for response from the eye alone, reminding us of our bodies only in a removed sort of way'.[5] Similarly, the contrapuntal basis of their formal arrangement invests Caro's figures with an architectonic quality. In this respect a potent source of inspiration was Le Corbusier's architecture and, in particular, the Ronchamp Chapel, 1950–5 (fig.2). The dynamic interplay of curve, mass and inclined plane which characterises Le Corbusier's masterpiece greatly excited Caro, in sculptural as well as purely architectural terms. This, and Caro's capacity to think of his own sculpture in an architectural way, points to the close relation of the two disciplines in Caro's mind, even before he

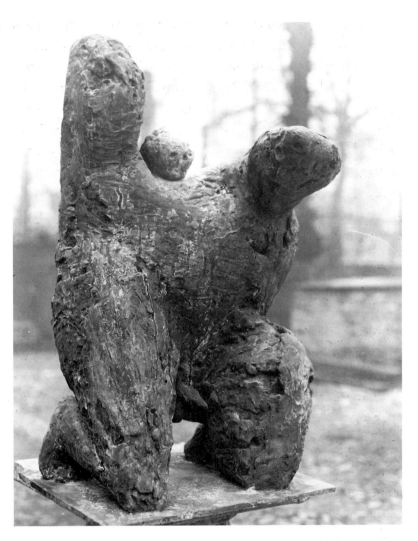

fig.1 *Man Taking Off his Shirt* 1955–6 Collection Phillip King, London

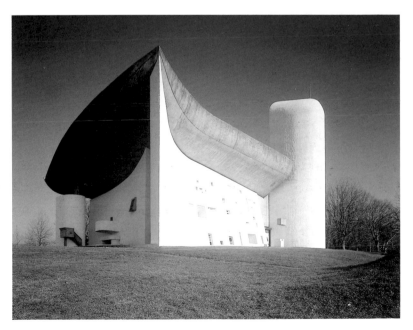

fig.2 Le Corbusier *The Ronchamp Chapel* 1950–5

relinquished figurative sculpture in favour of abstraction. The resulting cross-fertilisation of ideas was to be a crucial factor in his subsequent development.

A decisive moment was his meeting in 1959 with the American critic and leading apologist for Abstract Expressionism, Clement Greenberg. The two men met in Caro's London studio where the sculptor's work was discussed. Some indication of the ideas which Greenberg voiced can be gleaned from his essay 'The New Sculpture', first published in 1948 and revised the year before his meeting with Caro. The central thesis of this essay is that the aesthetic sensibility of the twentieth century is geared towards experience which is immediate, concrete and irreducible. 'To meet this taste', Greenberg argued, 'a modernist work of art' must strive for 'purity' in its means of expression. It must try, in principle, to convey experience solely through the elements of which it is comprised. Art can achieve this, Greenberg argued, by implementing a principle of 'reduction': that is, by 'renouncing illusion and explicitness. The arts are to achieve concreteness, "purity", by acting solely in terms of their separate and irreducible selves'.[6]

When Greenberg first wrote 'The New Sculpture' he saw that, of all the visual arts, abstract painting had made the greatest progress in attaining this objective. Nevertheless, he anticipated that because sculpture exists in the real, three-dimensional world and is therefore less illusionistic, it could rival and even overtake painting. Ten years later, Greenberg's revisions record his disappointment that sculpture's potential remained unrealised. 'Painting', he observed, 'continues as the leading and most adventurous as well as most expressive of the visual arts'. Significantly, however, he added: 'architecture alone seems comparable with it'.[7]

The implications of Greenberg's views on 'purity' and 'reduction' were clear. The expressive distortion which Caro had employed in his work for the preceding five years operated by *inference*. The spectator *reads* the sensations and experiences which are represented, and therefore mediated, by his figures' surfaces and formal characteristics. His discussion with Greenberg suggested that, like music, non-representational sculpture could express emotion and experience directly. The limitations of his present way of working became apparent but as yet Caro had little idea what form an alternative means of expression would take.

The solution to this problem emerged after a visit to America which Caro made in 1959. During the two months he spent there Caro met Greenberg again and also made a number of other important contacts. Of primary significance in this respect was his meeting with David Smith and the friendship he forged with Kenneth Noland. Although he was familiar with Smith's work from reproductions, the few examples of the older sculptor's welded constructions which he

saw impressed Caro deeply. In particular, Smith's way of working seemed to offer greater freedom, flexibility and directness than was possible using modelling and casting techniques. Similarly, Noland's paintings, based on the centrifugal rhythms and colour resonances of concentric target-forms (fig. 3), confirmed the expressive potential of abstraction.

'Twenty Four Hours', 1960 (fig.4) was executed shortly after Caro's return from the USA and is a forceful manifestation of Caro's complete conversion to abstraction. In some respects the influence of Noland and Smith is apparent. Caro's employment of basic shapes derives from Noland. In particular, the circular element with concentric rings painted on its surface recalls the American's target-form paintings. Also Caro's use of steel is clearly inspired by Smith. This, however, is the limit of these artists' influence. The degree of Caro's innovation is clear in relation to Greenberg's observation that

> To render substance entirely optical, and form, whether pictorial, sculptural or architectural, as an integral part of ambient space – this brings anti-illusionism full circle. Instead of the illusion of things, we are now offered the illusion of modalities: namely, that matter is incorporeal, weightless and exists only optically like a mirage.[8]

'Twenty Four Hours' implements these aims literally, but it does so in a way which already extends the direction taken by Smith and Noland. Caro addresses the question of making the work of art a part of real space in the most direct way possible. Unlike Smith's sculpture, which is pedestal-based, 'Twenty Four Hours' stands on the ground. As a result the sculpture is brought almost into the spectator's space. The work is experienced in an unmetaphorical way and we do not read it as a scale-representation of any other object. It exists in its own right and on its own terms. Any sense of an illusion of its existence in the real world is eliminated completely.

left
fig. 3 Kenneth Noland *Gift*
1961–2 Tate Gallery
right
fig.4 *Twenty Four Hours*
1960 Tate Gallery

Instead, as Greenberg's statement suggests, the illusion in 'Twenty Four Hours' relates to the nature of our experience of this real object. If we stand directly in front of it the square and circle appear to float behind the polygon. This mirage of weightlessness is more vivid than Noland's paintings of target-shapes hovering in an undefined space because Caro's forms have a tangible reality in our own world. Nevertheless, in order to sustain this illusion, the work has to be seen face-on. When we walk around it the means of its construction are apparent and the illusion vanishes. 'Twenty Four Hours' is thus a very 'frontal' work and in this sense it tends towards the pictorial in the way it defines space.

This is a characteristic shared by several of the sculptures which Caro made during 1960 and 1961 and Caro has cited the influence of Morris Louis's veil paintings (fig.5). 'Second Sculpture', 1960 (fig.6), for example, consists of sheets of steel which rise from a lengh of I-beam placed along the ground. It is predominantly flat and vertical in its orientation. Caro seems to have been dissatisfied with the limitations imposed by this too strict adherence to a two-dimensional approach. 'Midday', 1960 (fig.7) and 'Sculpture Seven', 1961 (fig.8), arguably the outstanding works of this period, both reflect a desire to create works more fully in the round. Greenberg had asserted that to render substance entirely optical, form could be pictorial, sculptural or architectural. This development in Caro's sculpture is important because it represents a swing away from a pictorial articulation of space, and a gravitation towards sculpture which organises space in a way which relates more closely to architecture.

'Midday' and 'Sculpture Seven' both have greater physical depth. The spectator experiences the changing relations of their parts by walking around the works. This is apparent in 'Sculpture Seven' in which two short lengths of I-beam jut out at right angles from their three larger neighbours. Both works also herald Caro's emphasis on a horizontal configuration. In 'Midday', all the smaller elements are inflected from, and supported by, a length of girder angled above the

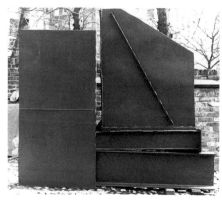

left
fig.5 Morris Louis *VAV*
1960 Tate Gallery
right
fig.6 *Second Sculpture* 1960
Private collection

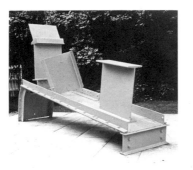

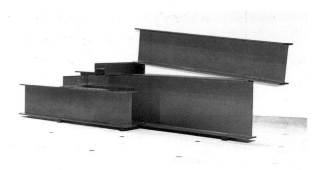

ground. This insistent horizontality is even more obvious in 'Sculpture Seven'. Two massive I-beams appear to float just above the ground, supporting other beams which are oriented parallel, or almost parallel, to the ground.

Caro's intention in eliminating totemic configurations was to stress the completely abstract nature of these works. He wished to remove any suggestion of the human figure in order that these sculptures might be as unrepresentational as possible and purely expressive, solely in terms of the relation of their parts. Nevertheless, 'Midday' and 'Sculpture Seven' are both monumental in feeling. They occupy space rather than defining or enclosing it. This has led commentators to perceive in these works echoes of Moore's reclining figures, an interpretation which Caro has always resisted. It was perhaps considerations of this kind which persuaded Caro to extend the architectonic implications of his figurative works and to develop, in his abstract sculpture, a greater emphasis on organising *space*. Caro later stated: 'The reason for opening sculpture out was to make it more fully abstract, as music is abstract'. This means of expression is more obviously allied to architecture than that previously explored in 'Midday' and 'Sculpture Seven' because, as Caro has remarked, 'Architecture is the art that controls and uses space'. Investing his sculpture with an architectonic character also eliminated figurative references completely and permitted greater purity of expression for, as Caro recognised, 'Architecture is perhaps the purest abstract visual form'.

As the following statement by Caro indicates, he did not evolve architectural concerns *per se* as part of a deliberate programme.

We sculptors were absorbed with getting away from old fashioned methods and models, and with making a new vocabulary for sculpture. The realisation of the closeness of what we were making to architecture would at that time have horrified us – taken away from our endeavour. Nevertheless we were using rods that felt like handrails even though they were not grasping, making intervals like doorways even though one couldn't go through them, enclosing space in works that felt like rooms even though one could explore them with the eyes only.[9]

Implicit in this statement is Caro's realisation of some of the essential differences between sculpture and architecture. Sculpture aspires to pure expression without the burden of function. It creates objects invested with the experience of their creator which are an end in themselves. Moreover, in expressing 'human feeling, eye, brain and heart' through the relation of form and space, the spectator's eye alone is sufficient. With the exception of recent developments which invite physical participation, the experience of Caro's sculpture is entirely optical. In contrast, architecture, though possessing an equal capacity for pure formal expression, is essentially functional: the space it creates is for habitation. This aspect of Caro's sculpture can therefore be thought of as architectonic. That is to say, it employs the means, materials, elements and principles of architecture. And it addresses the same subject – the relation of form and space in a way which makes sense in human terms – while remaining essentially sculptural: 'a thing in and of itself'. This is the context in which Caro's development will now be considered.

'Lock', 1962 (fig.9) demonstrates the speed and authority with which Caro developed this sculptural aesthetic. As in architecture this is based on the complex orchestration of shapes, masses, the spaces these define and enclose, angles, lines of direction and, most significantly, the relation of the horizontal organisation of the work – its ground plan – to its vertical elevation. In 'Lock' Caro achieves a greater lateral dispersion than before. The sculpture spreads out directly on the ground, claiming ninety square feet of space by means of two girders placed alongside each other. One of these rises gently, animating the relation of the two parts. In so doing it affirms the fundamental difference between the sculptor's and the architect's activity: 'architecture sits grounded, sculpture flies'. Underwriting Caro's annexation of architectural elements is his freedom to dispose elements expressively, intuitively, and as part of an improvised process governed by choice rather than necessity. A length of I-beam set at an angle between the two girders establishes a strong directional sense and leads the eye through the work. A level beam passes above and across these elements at their midpoint. This frames a space which they penetrate, thus emphasising the work's depth and the impression of opposed, as well as rhyming, elements.

In 'Sculpture Two', 1962 (fig.10) the relation of ground plan and elevation is more complex. Again the area covered by the sculpture is large, almost the same as that of 'Lock'. In 'Sculpture Two', however, beams laid along the ground create zones of lateral space. As a result, the floor – a fundamental consideration in architecture – is brought into play as part of the overall interaction of linear elements and space. The eye is led upwards by ascending beams which frame polygonal spaces in their relations with the ground. The dialogue between ground-based and vertical beams conveys a sense of ground plan and elevation

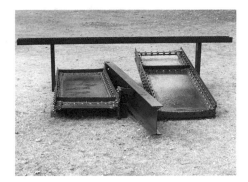

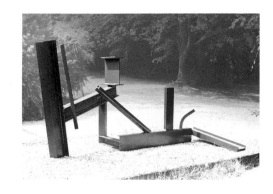

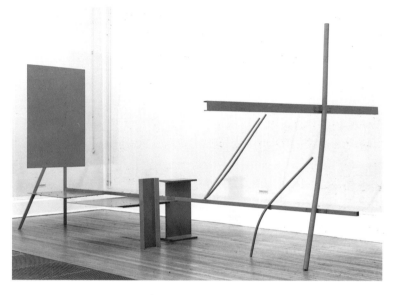

fig.11 *Early One Morning*
1962 Tate Gallery

acting in concert. The changing relations of these elements, which unfold as the spectator walks around the work, introduces a time-based narrative element. In this way the work's formal organisation is akin to music as well as to architecture. The interrelation of architecture, sculpture and music is a fundamental idea in Caro's aesthetic. The fugue – a musical composition in which an idea is stated by one element, and then developed and interwoven by others – is particularly germane to an understanding of his creative processes. 'Sculpture Two' demonstrates this in the way that the vertical elevation develops and varies the ideas introduced by the lateral arrangements of its parts.

The opening up of space and the introduction of time as an element in the experience of formal relationships was extended in 'Early One Morning', 1962 (fig.11). The work is surprisingly economical in its means, being composed entirely of a few planes and linear elements. Nevertheless, it conveys an impression of expansive openness. This is due to Caro's success in using plane and line to define space. The vertical rectangle at one end acts as a terminating wall

while, at the other extreme, a horizontal beam implies the limits of the sculpture in this direction. Between these two elements a second beam, twenty feet in length, leads the spectator's eye through a space which is variously animated by the horizontal, vertical and linear shapes it encounters en route. As in 'Sculpture Two', parts in contact with the floor define the ground plan as a compositional participant. The presence of the long horizontal beam and flat planes floating above the ground also divides the space above the ground into two zones. Caro has described how he deliberately made this piece long. As a result the time taken to explore its spatial implications is protracted and the amplitude of its changing relations widened. An aspect of this is Caro's exploitation of perspective. Seen first along its length it comes as a surprise to discover the depth of this piece as we move around it. This order of experience is familar in an architectural context. But, with the exception of Donatello's development of implied recession in his bas-reliefs, Caro's use of deep space as a compositional element was without precedent in a work of sculpture.

A problem entailed by orienting forms vertically is that planar elements tend to obscure the viewer's sightlines. This is avoided in 'Early One Morning' by positioning the large rectangular plane at what we take to be the back of the sculpture. Between 1964 and 1966 Caro proposed a number of different ways of enclosing space and it is illuminating to trace his development of a sculptural equivalent for a basic architectural element: the wall.

In 1964, Caro executed a series of three related sculptures: 'Titan' (fig. 12), 'Bennington', and 'Shaftsbury' (fig. 14). The main characteristic of each of these works is a long, low-lying, vertically oriented panel. This acts as a wall, dividing space and, by means of the various angles which inflect its course, implying the enclosure of space. In 'Titan', for example, the single bend in the panel establishes, on one side a right angle, and on the other an angle of 270 degrees. We tend to read the former as 'inside' and the latter as 'outside'. Caro has dealt with the problem of obscured sightlines by reducing the height of the vertical panel: the highest point reached by any of the sculptures is forty-one inches. Instead the emphasis is on ground plan: the spaces defined on the floor assume a greater prominence than in previous works. Within these areas Caro has positioned incidental, punctuating elements in the form of I-beams or, as in the case of 'Titan', a shape formed from smaller, angled panels. These create intervals and niches: Caro's equivalent for the 'quiet, still resting places for the spectator' which he had identified in Donatello's sculpture.

The possibility of a permeable wall, a plane which divides space but through which the spectator can see, is advanced in 'Homage to David Smith', 1966 (fig. 13). Again this work is essentially ground-based: the eye travels along and ascends through a sequence of I-beams. The low-lying wall which these create is

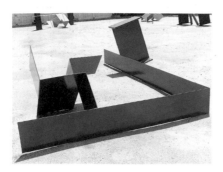

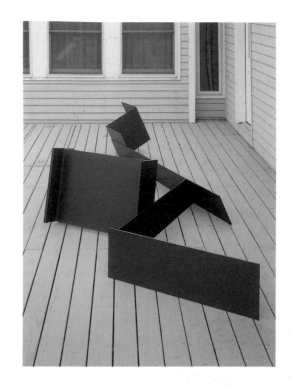

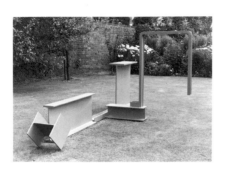

divided at its midpoint by a further I-beam set at right angles. From this, a cantilevered beam rises to a height of ten feet, describing in the air a form resembling an arch or doorway. As this form does not reach to the ground we are invited to complete the shape imaginatively. Moreover, since Caro does not intend that the spectator should actually pass beneath this gate shape it may also be read as a linear element framing a spatial plane. It *implies* a transparent wall.

Caro extended this concept, and found a physical equivalent for it, in his use of mesh panel. This element was first used in 'Aroma', 1966 (fig.15) and subsequently employed in a trio of works, 'Carriage' 1966, (fig.16), 'The Window', 1966–7 (fig.17) and 'Source', 1967 (fig.18). The mesh defines space without obscuring other elements. The works enclose an area at their centre. And by employing forms which have a human scale and are situated in the spectator's space, they manifest Caro's idea of sculptures which 'felt like a room even though we could explore them with the eyes only'.[10] The title of 'The Window' embodies the idea of looking through and into a separate space. In this work a number of different elements – the ground-based beam, the triangular plane, the mesh rectangle, the vertical beam, and so on – lead the eye around and into this central area. An optical entrance, too small for physical entry, is formed by the gap at one of the work's corners.

'The Window' is predominantly vertical in its orientation and is one of Caro's most satisfying explorations of forms organised in this way. Although he continued to investigate the delineation of vertical planes, the theme of horizon-

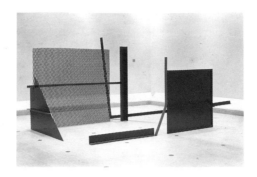

fig.15 *Aroma* 1966
Private collection, London
below left
fig.16 *Carriage* 1966
Collection Henry and Maria
Feiwel, New York
right
fig.17 *The Window* 1966
Private collection, London
below right
fig.18 *Source* 1966
The Museum of Modern Art,
New York, Blanchette
Rockefeller Fund

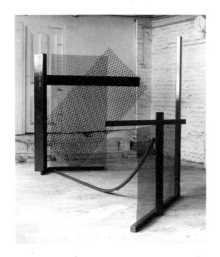

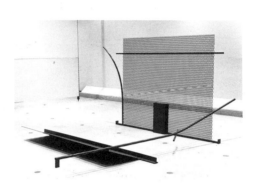

tal elevation assumes greater prominence in the works which Caro made between 1967 and 1970. He proceeded to explore sculptural forms which relate to architectural elements such as platforms and ceilings in the way they define space. This development is evident in works such as 'Prairie', 1967 (fig.19) and 'Deep North', 1969–70 (fig.20). In 'Prairie' a vertical plane set at right angles to a low-lying panel suggests a box-like space at one corner. This forms an effective contrast to the two horizontal levels which occupy the adjacent area. The lower level is formed by a corrugated panel. Sloping planes at either side of this lead the eye to the work's most impressive invention, a plane described not by mesh or by a framing element but by a series of parallel rods which articulate its form from within. Set at waist height, the spectator is able to look down upon and through an implied surface. The way these different levels animate space introduces a dimension which, though fundamental to architecture, was previously unknown within the vocabulary of sculpture.

'Deep North' represents something of a climax in Caro's development. It extends his exploration of the emotive power of horizontal levels and also of the capacity of forms to suggest space. The great length of the piece only partially accounts for its impressive presence. Essentially this is due to the dramatic

contrast which Caro draws between the horizontal planes at either end. The lower form is set at table-top distance from the ground. This amplifies our sense of height as our eyes are swept up to a second, mesh level which towers above the spectator. Although transparent, this element functions as both platform and ceiling, associations forced by the spectator's literal relation with the form. Caro's command of spatial description is manifest in the way that he is able to suggest a room-like space, directly beneath it, using only this single plane.

By 1970 Caro seems to have reached a point where many of the sculptural concerns which had preoccupied him during the previous ten years had been resolved. At the same time he reached a new level of critical acclaim with the success of a one-man show held in New York during that year. This permitted Caro to take stock of the ground he had covered. During the early part of the decade his output increased as older themes were re-examined and new ideas were tried out, producing a body of work which is remarkable for its breadth, invention and diversity. Simultaneously his engagement with the architectonic aspects of his work intensified. 'When the 70's and 80's came along', Caro has observed, 'the architectural became more specific, more explicit'.

Between 1971 and 1974 Caro executed a series of sculptures, based on the saw-horse motif, which developed his interest in the relationship of sculpture, architecture and music. 'Ordnance', 1971 (fig.21), the first of these works, announces their central theme. This resides in the contrapuntal relationship of linear horizontal elements set against the regular rhythm established by the saw-horse legs. In musical terms this might be compared to a sustained chord punctuated and animated by an underlying sequence of beats. In his book *Philosophie der Kunst* (1809) the German philosopher Von Schelling observed that 'Architecture in general is frozen music'. The marriage of forms working in harmony and opposition is a central principle in the architectonic organisation of Caro's sculpture.

A further development at this time, evident in 'Ordnance', was Caro's gradual abandonment of painted steel in favour of a rusted or varnished finish. Paint had been used previously to unify the disparate elements in a work and also to deny

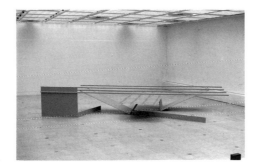

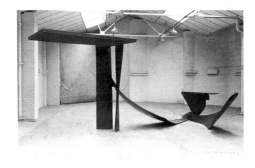

left
fig.19 *Prairie* 1967
Private collection,
Princeton, New Jersey
right
fig.20 *Deep North* 1969–70
Private collection, New York

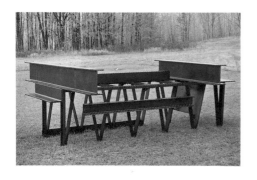

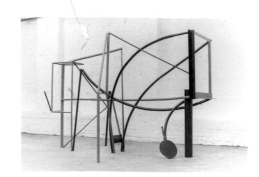

the impression of weight inherent in steel. Leaving the sculptures unpainted reaffirmed their weight and introduced a new monumentality. This interest in the undisguised character of steel subsequently received a fresh charge of inspiration. At the end of 1972 Caro visited the Rigamonte steel factory at Veduggio near Brianza in Italy. For the first time he was able to work with sheet steel produced straight from the rolling mills. The huge flattened plates of rolled metal with their curved and torn edges provided Caro with a markedly different sculptural vocabulary which fired his imagination.

Despite this break with regular geometric shapes in favour of plate steel in a more 'natural' state – torn, buckled and patinated – an underlying architectonic organisation is apparent. Throughout the Veduggio works massive irregular shapes are brought together in ways reminiscent of walls, steps, gateways and arches. 'Veduggio Sound', 1972–3 (fig.23) is overtly architectonic in its construction. The post and lintel forms which frame its central space are married with a central supporting wall. These monumental constructions are nevertheless invested with a sense of human scale which perhaps accounts for their emotive power.

The fifteen 'Emma' sculptures which Caro executed near Emma Lake in Saskatchewan in 1977 could hardy be more different in their articulation of space. In contrast to weight, monumentality and solid planes, works such as 'Emma Dipper', 1977 (fig.22) are light, brisk and open. Like a line-drawing in air they enclose space in a cage-like form of implied, interpenetrating planes. In 'Emma Dipper' a square frame at one end of the sculpture provides a visual entrance to the linear enclosure. Caro's use of metal tubing in many of the Emma works connects them with Picasso's wire constructions of 1928–9 but their description of space, in terms of fragmented planes, relates them more closely to Cubism.

Caro's engagement with the relation of sculpture and architecture found a new synthesis during the early 1980s. Again, the inspirational power of fresh materials is apparent. Caro began to use massive buoys, chain links, bollards and other elements taken from marine dockyards. In works such as 'Sheila's Song'

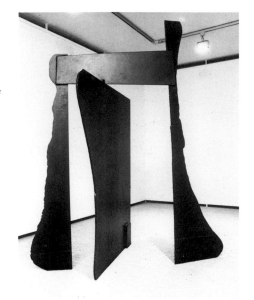

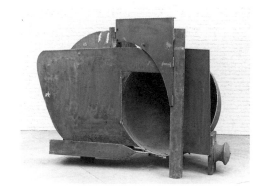

(fig.24) and 'Tuba', both 1982, Caro embarked on a renewed exploration of the relation of flat plane and enclosed space. The imposing physical nature of these materials invested this marriage of contrasting elements with greater dramatic force. Like his earliest abstract sculptures, 'Sheila's Song' at first sight appears to be a very frontal work. Face-on the spectator is confronted by a heavy plane of steel. A window-like square cut into this frames a shadowy recess whose depth only becomes apparent as the spectator moves around the work and discovers a new space-enclosing element in Caro's vocabulary: a halved buoy. This relationship of the human, implied by the rounded niche whose scale and shape seems to invite habitation, and the geometric, evident in the shapes and planes which frame this space, is a central issue in architecture. It is also the main theme of 'After Olympia', 1987, the largest of the works inspired by Caro's visit to Greece.

Caro's decision to travel to Greece in order to experience classical art *in situ* was accompanied by a fear that he would be disappointed. Instead, the effect of the sculpture and architecture he saw was both revelatory and inspirational. Caro observed:

> The light and the temples sited in their landscape made me see Greek art in a completely different way from studying photographs; the art and the history belong together. For me the most wonderful are the archaic sculptures, and also the pediments and metopes of Olympia. Instead of the separate sharded parts, that I knew from my studies, I now saw the sculptures more as they were originally conceived – sensual rolling forms and figures contained and even forced into strict architectural shapes. The contrast of the volumetric moving forms is set against the crisp and geometric.[11]

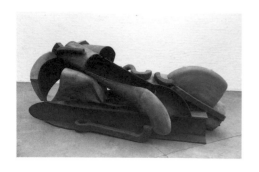 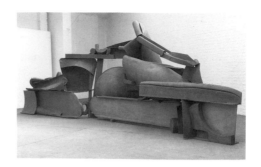

As this statement indicates, Caro's interest in the relation of sculpture and architecture now became focused on the way rounded and rich sculptural forms are contained within an architectural setting. Following his return to London Caro executed two sculptures, 'Scamander', 1985–6 (fig.25) and 'Rape of the Sabines', 1985–6 (fig.26), in which large masses of buckled and twisted steel are assembled within an implied pedimental surround. In 1987 he also embarked upon the 'Measure' series of table-pieces, following this in 1988 with the 'Final' series, both of which form sets of variations on the containment of sensual shapes within a rectangular metope form. The principal expression of Caro's engagement with this theme is, however, 'After Olympia', 1987 (colour plate, p.35).[12]

'After Olympia' is the largest sculpture Caro has ever executed. For several years he had wanted to attempt 'a kind of "War and Peace" sculpture', a work which would present a new challenge in terms of size and complexity. However,

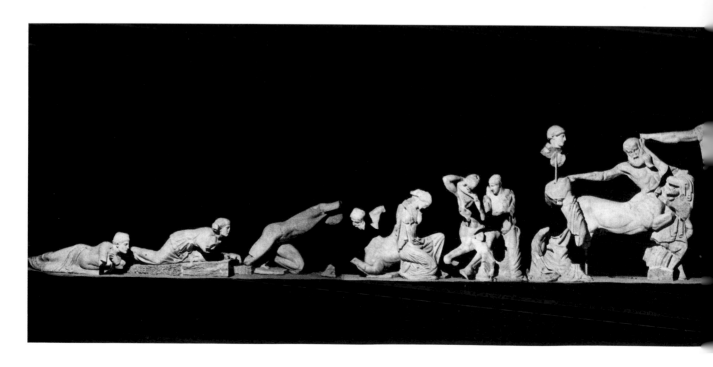

it was not until 1986, when his studio had been cleared for a one-man show in London, that Caro had the inspiration, the necessary space, and the vast resources of steel required, to attempt such an undertaking. Caro commenced the construction of 'After Olympia' by rigging up lengths of string in order to determine its dimensions and pedimental shape. Its execution then proceeded according to his usual way of working, in an improvised fashion and without drawings or models. The sculpture was assembled along the floor, each piece having to be hoisted into position either to take its place within the whole or to be rejected if unsuitable. A principal difficulty involved in the selection of pieces was the question of size. Each piece had to maintain a sense of relation, scale, direction and feeling while also physically fitting within the overall structure at a particular point. A further problem was in seeing the work as a whole. (This recalled Caro's earliest sculpture which he made in a small garage.) Consequently the entire work had to be moved into the open air outside the studio. The sculpture was then raised onto a plinth in the form of a long, connecting flat bed. This is not straight but incorporates a gently curving entasis.

Although inspired by a figurative source there is no literal equivalence between the pedimental sculpture of the Temple of Zeus (fig.27) and 'After Olympia'. The forms which comprise the latter are fully abstract and expressive in their own right. Massive, softly folded, rigid in places and occasionally floating lightly, they possess a Rubens-like sensuality which is both monumental and intimate. However, as in the original, these elements are distinct and, for the

fig.27 *West pediment of the Temple of Zeus at Olympia* Olympia Museum

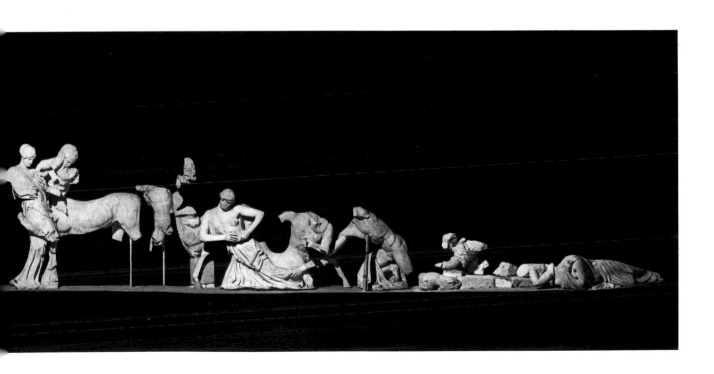

most part, physically separate sculptures. The challenge posed by the Olympia pediment, to which 'After Olympia' responds, is to invest these separate elements with a sense of unity, so that the individual forms may be felt to bear an integral relation to each other, to the whole, and to the pedimental surround. Although the latter is not present in Caro's sculpture, it is suggested by the way the forms rise from the sides and meet at the highest point in the centre. As in the original, this marriage of the voluptuous and the geometric invests 'After Olympia' with a sense of 'richness contained'.

'Xanadu', 1986–8 (colour plate, p.42) was executed after 'After Olympia' and was intended as a pendant to the larger work. Like 'After Olympia', the original conception was for a pediment-type work in which sensual shapes are related to each other in a way which suggests containment within a triangular architectural surround. As such, elements used in 'Xanadu' and 'After Olympia' were taken from the same stock, although 'Xanadu' contains a few more forged parts. Despite its smaller size (although at twenty feet long it is still a formidably large work) 'Xanadu' took longer to complete than 'After Olympia'. According to Caro, the work itself 'took over' and during the course of its two-year evolution it went through many changes before attaining its final form.

That 'Xanadu' changed in this way demonstrates how the nature and disposition of individual elements radically affect the character of the whole. The internal relations which developed between different forms means that, overall, only an echo of a pedimental arrangement now exists. This may just be discerned in the subtle ascent of forms towards what would have been the centre of the pedimental shape, now situated at the extreme left of the sculpture. The impetus for these changes is related to the growth of the work on an imaginative level. Caro feels that 'Xanadu' gradually came to associate itself with one of his favourite paintings, Matisse's 'Bathers by a River', 1916–17 (Art Institute of Chicago) (fig.28). Comparison of the two works reveals certain formal connections. For example, the upright form at the left of 'Xanadu', which incorporates a section of a buoy, relates to the bather at the left of the painting; the vertical plane to the right of this suggests the band of black running through the centre of the Matisse; the adjacent buckled steel element evokes the bent knee of the seated bather; and the expanse of white in the 'Bathers' finds an echo in the way the structure of 'Xanadu' opens out at a similar point.

Despite this association, as in 'After Olympia' no literal correlation between abstract and figurative elements is intended. Like 'After Olympia', the central concern of 'Xanadu' is architectonic in character, namely the relation of sensual forms and geometric shapes. Large rolled forms and convex shapes seem almost to wrap themselves around angular planes of steel. Though no longer directly inspired by the relation of pedimental sculpture and architecture the composition

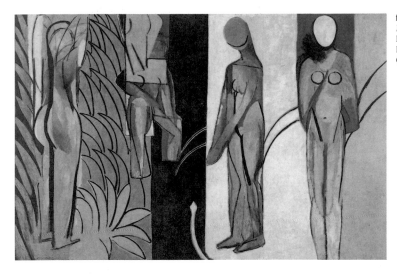

fig.28 Matisse *Bathers by a River* 1916–17 Art Institute of Chicago. Charles H. and Mary F.S. Worcester Collection

of 'Xanadu' recalls the sense of architecture which Caro, as already seen, had identified in Donatello's sculpture. Like the 'David', 'Xanadu' evokes a 'building with front [and] back . . . elevations. The forms inflect against the datum of flatness'. Moreover, although massive, 'Xanadu' is invested with an indeterminate sense of human proportion, implicit in the intervals between its large forms and in its niche-like spaces. This quality finds expression in its title, taken from Coleridge's poem, *Kubla Khan*, which begins:

> In Xanadu did Kubla Khan
> A stately pleasure dome decree
> Where Alph, the sacred river, ran
> Through caverns measureless to man
> Down to a sunless sea

'Xanadu', Caro has observed, 'concluded the "After Olympia" series. And by being different in the end, it kind of pushed me on'. As Caro had often found in the past the impetus for a new challenge was provided by engaging with an unfamiliar vocabulary of sculptural elements. Among the large pieces of crushed steel which Caro had imported from Holland, some of which had been employed in the making of 'After Olympia' and 'Xanadu', were a number of volumetric pieces in the form of curved and bent tubes. Initially Caro felt these were unusable and he put them to one side. Subsequently, however, their volume seemed appropriate to a fresh source of inspiration for Caro: the paintings of Courbet.

'Night Movements', 1987–90 (colour plate, p.40) expresses Caro's admiration for the sense of weight and density which he found in Courbet's work. The emphasis, evident in this piece, on volume and vertical orientation relates to a

central Courbet motif: the tree. Underlying Caro's employment of elements which have an organic character there is, however, an extension of older concerns of an architectonic nature, notably the relation of elevation and ground plan. In 'After Olympia' Caro had been concerned with the question of how to invest physically separate elements with a sense of unity so that they cohered as a single sculpture. In 'Night Movements' this is a central preoccupation. This work is composed of four distinct freestanding units whose relative positions are determined by the use of a template. Each part relates to and complements the others in a way analogous to, for example, the separate movements which comprise a single musical composition. At the same time disposing the pieces in this way articulates and animates space, so that the intervals between the different units become an active part of the overall conception. This investigation of the relation between vertical elements, the spaces between them, and ground plan extends concerns which have figured in Caro's work from its beginnings. However, because the spectator may walk between the work's individual parts, 'Night Movements' invites a closer degree of physical participation between the viewer and the work. And in this respect 'Night Movements' relates to concerns explored more overtly in Caro's 'sculpitecture'.

Caro's exploration of the relation of sculpture and architecture may, in one sense, be seen as a testing of the boundaries of these disciplines. By the beginning of the 1980s Caro's interest in the architectonic aspects of his sculpture had taken him to a point where, as he described it, 'the edges blur'. Pushing to its literal conclusion his conviction that 'sculpture and architecture may be nourished by one another' Caro conceived of sculpture which required the physical participation of the spectator. That is to say, sculpture which the viewer may enter, inhabit and explore, discovering the relation of its forms internally as well as externally, and measuring its proportions against his or her own body as part of the total experience of the work. Nevertheless, Caro's aim was not to create architecture. Rather, he saw this endeavour as 'a deliberate attempt to broaden the borders of sculpture': the works of which he conceived 'had to be . . . sculpture, not architecture, not too rooted on the ground, more fly-away'. Moreover, this kind of activity would constitute only one aspect of his work. In order to distinguish it from the main body of his sculpture, which remains purely 'optical', commentators have adopted the term 'sculpitecture'.[13]

The first of his sculpitecture works was the 'Child's Tower Room' (fig.29), an Arts Council commission which Caro created for the *Four Rooms* exhibition at Liberty's, London in 1984. In 1987, he collaborated with the architect Frank Gehry in the construction of a 'sculptural village'. This was followed, in 1988, by the execution of two half-scale sculpitecture projects: the 'Lakeside Folly' (fig.30) and the 'Pool House' (fig.31), both executed in plywood in the grounds of Caro's

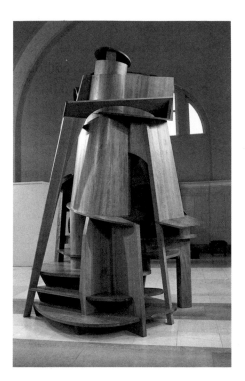

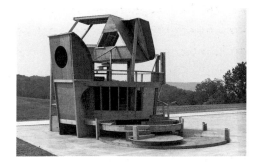

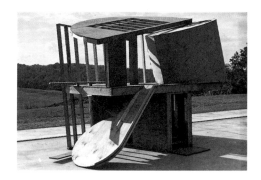

studio in upstate New York. 'Octagon Tower – Tower of Discovery', 1991 was commissioned for the present exhibition and is its centrepiece (colour plate, p.45).

In late 1990 Caro was invited by the Tate Gallery to make a new work specifically for installation in the central space of the Duveen galleries, the Sackler Octagon. Although Caro's original intention was to create a full-size version in wood, in practice the growing complexity of the project rendered this impossible. Consequently he decided to work in steel. This was quicker and permitted greater flexibility. This decision also meant that the construction of the work could take place in Caro's London studio. He began by constructing a one-third scale model in steel. The basic form of 'Octagon Tower' was worked out in advance on this maquette. As the construction of the full-size tower got under-way in the studio, he was then able to advance both simultaneously, making decisions and trying out ideas on the model as necessary.

Caro's use of a maquette was a radical departure from his usual practice. This was necessitated by a degree of precision in the construction of 'Octagon Tower' which established a precedent in his sculpture. In purely formal terms the sculpture is a network of inclined planes, curved and irregular shapes, abutting angles and small, detailed elements, each of which relate to each other, or are physically joined, seamlessly and precisely. As such, its execution – a formidable achievement in engineering terms alone – required the labour of a team of skilled welder-fitters working under the close supervision of Caro and his Studio Manager, Pat Cunningham.

In essence, 'Octagon Tower' is about staircases conceived as sculptural elements. Five of these are visible from the outside of the tower; a sixth, spiral, staircase is enclosed within the central column which forms its spine. In addition there are three levels, or viewing platforms: a lower mezzanine, a first-middle stage, and a second floor at the top. Access to all parts of the sculpture and its interior spaces is provided by the staircases. The 'main' staircase, nearest the central column and at its right-hand side, takes the spectator to the top of the tower. It is then possible to enter the central column and descend to the first floor. An outer staircase at the extreme left of the sculpture returns the spectator to the ground. The outer staircase at the extreme right ascends to the first floor and the inner staircase to the left of the central column gives access from the ground to the mezzanine. A small staircase connects the mezzanine with the first floor. The spectator may also enter the sculpture via a rear vaulted area at its base. Seated in this small interior the spectator has a view upwards through the central column so that the steps of the spiral staircase, seen from below, appear like radiating petals.

The spectator is thus able to occupy the sculpture and to move within its interior. By ascending and descending its staircases, and through inhabiting and exploring its different spaces and formal relations, the spectator acquires an understanding of the work's internal character. This complements their knowledge of its exterior gained from walking around it. This experience is deepened by the physical and emotional responses which the work elicits from the spectator. A principal concern of 'Octagon Tower' is the experience of spaces and places. As the spectator explores the sculpture, he or she must negotiate staircases which become progressively narrow, being forced to alter the shape of the body in order to squeeze through its connecting passages. Similarly, the work's different levels and interior spaces, and the relatively confined area of the spiral staircase within its central column, impart a variety of spatial experiences and different vistas. Throughout, apertures, eyelets and slits admit light and permit views of other spatial and formal configurations.

'Octagon Tower' is rich in its complexity. Its formal composition sustains a fine tension between elements which are both freely expressive and purely functional. Though monumental it is permeated with a sense of human proportion. Outwardly open, the spaces enclosed within its interior are quiet, intimate and surprising. Witty and exploratory, it poses serious questions about our understanding of the nature of sculpture and the way we relate to it.

During the 1960s Caro's innovations heralded a revolution in sculpture. Within a remarkably short period, conventional ideas relating to materials, method, surface and finish, scale, form and space, composition and the relation of the work to the spectator – to name but a few concerns in sculpture – were

influenced by Caro's radical approaches. Few areas of the sculptor's practice have been untouched by his example. As a result, Caro has expanded the vocabulary of sculpture and hence widened the range of experience which sculpture can express. A central aspect of this endeavour has been his exploration of the relation of sculpture and architecture. And in this respect, Caro's role has again been that of the pioneer. Caro's achievement has been to broaden the boundaries of these disciplines, drawing them into a complementary relationship, so that sculpture and architecture 'can influence one another and each grow from that influence'.

In a lecture delivered at the Tate Gallery in 1991 Caro argued the need for greater reciprocation between sculpture and architecture. 'In the Renaissance', he observed, 'architect and sculptor worked closely, often practised both disciplines'. In Caro's view this 'communion of thought'[14] is an ideal to which these arts can aspire. The implications of this idea and of the sense of architecture which informs his work has significance for sculptors and architects alike. Caro's development of sculpitecture manifests this ideal. Executed in a characteristic spirit of exploration, the importance of Caro's continuing investigation of the boundaries of sculpture is reflected in his observation that 'if it succeeded . . . it could cause a kind of revival of energy in art'.

Notes

[1] Quoted in *Le Corbusier: The Artist The Writer*, Editions Du Griffon, Neuchatel, Switzerland 1970, p.110.

[2] Unless otherwise stated, all quotations are by the artist in letters to the author dated 5 February 1991, 25 March 1991 and 26 April 1991, all in the Tate Gallery Archive.

[3] Anthony Caro, 'Some Thoughts after Visiting Florence', *Art International*, May 1974, pp.22–3.

[4] Ibid.

[5] Ibid.

[6] Clement Greenburg, 'The New Sculpture', reprinted in *Art and Culture*, London 1973, p.139.

[7] Ibid., p.143.

[8] Ibid., p.144.

[9] 'Through the Window', lecture given by Anthony Caro at the Tate Gallery, 13 March 1991.

[10] Ibid.

[11] Anthony Caro, foreword to exhibition catalogue, *Anthony Caro Major New Work*, Richard Gray Gallery, Chicago, April–May 1989.

[12] The later 'Descent from the Cross' sculptures (1987–8) also explore the relation of sculptural forms and geometric shapes, the latter in the shape of the cross. Unlike Caro's sculptures based on pediments and metope forms, the cross-shape is married with sculptural forms rather than containing them.

[13] This term arose during a conversation between Anthony Caro and Karen Wilkin.

[14] Caro, 'Through the Window' lecture.

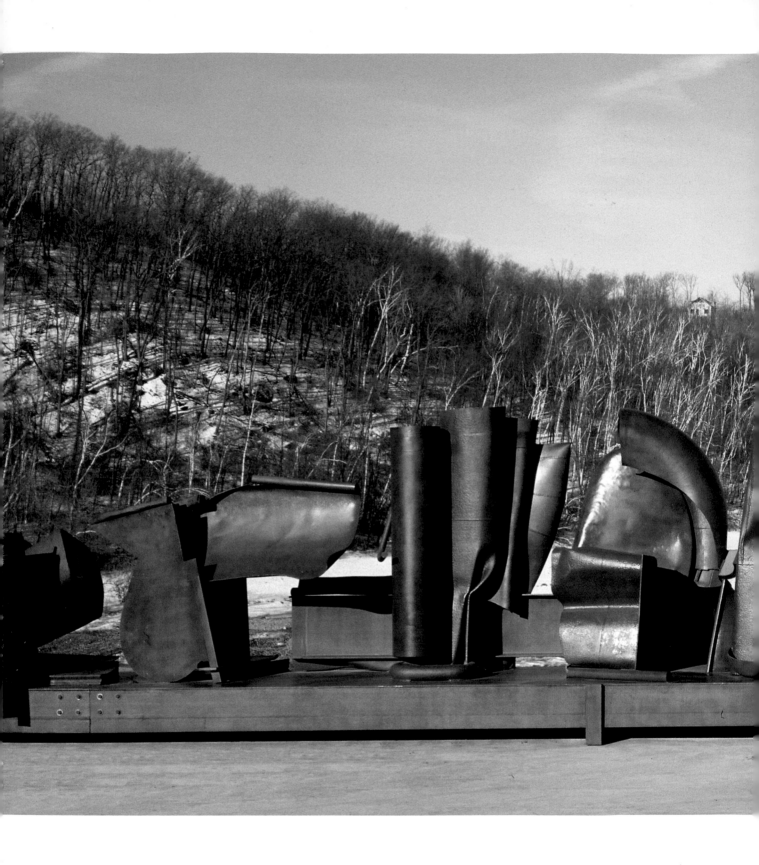

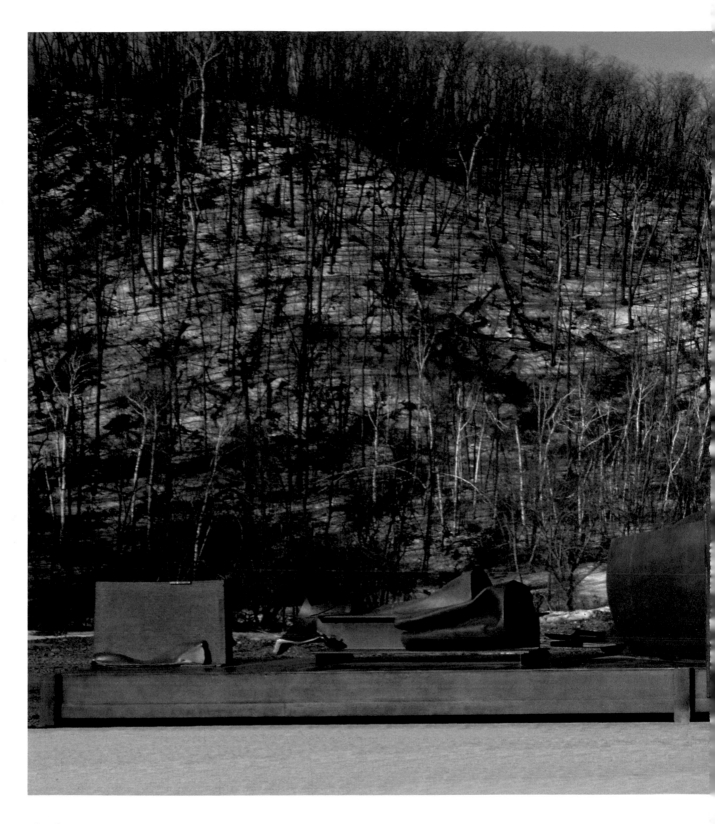

After Olympia 1987
Steel, varnished and painted
332 × 2342 × 170 cm (130¼ × 922 × 67 in)
Collection EPAD, Paris

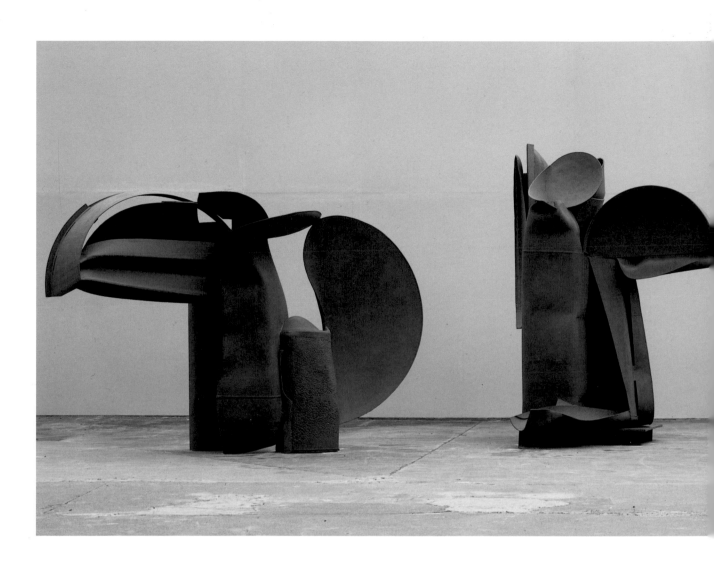

Night Movements 1987–90
Steel stained green, varnished and waxed
276 × 1077 × 335 cm (108$\frac{11}{16}$ × 424 × 131$\frac{7}{8}$ in)
Annely Juda Fine Art, London and
Galerie Lelong, Paris

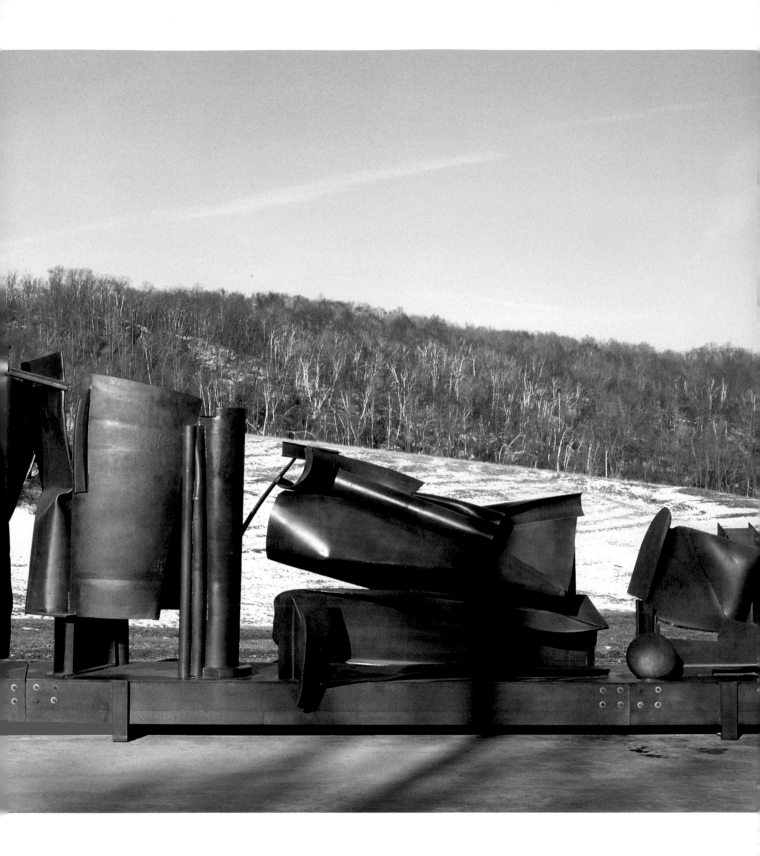

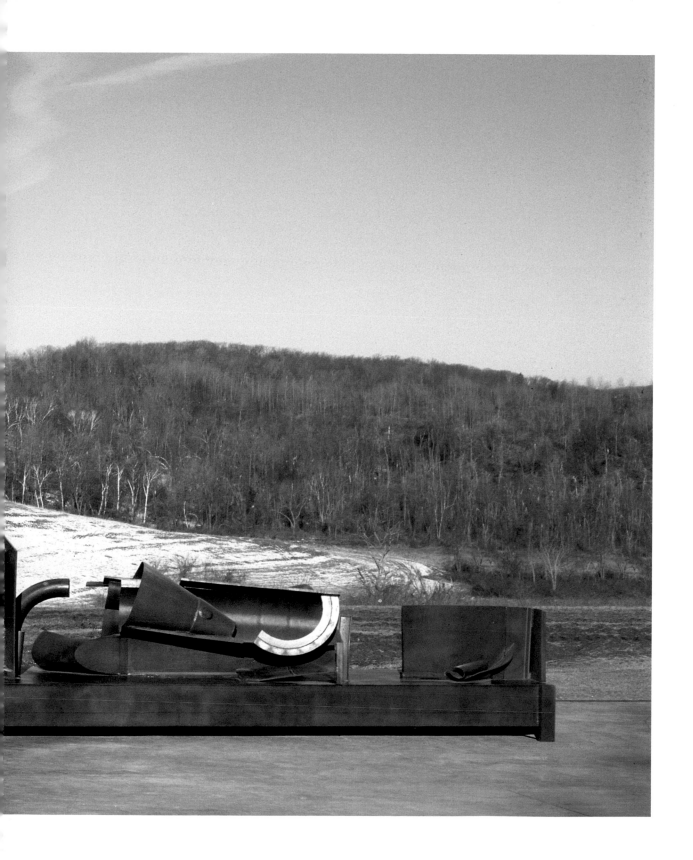

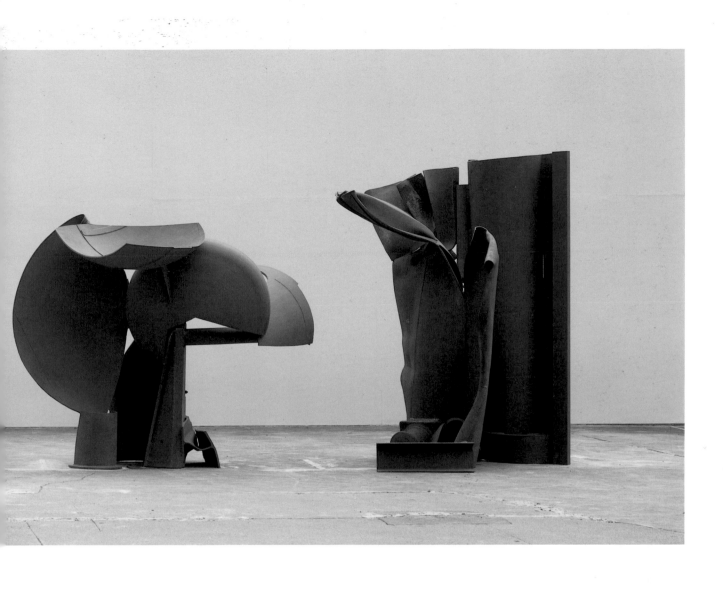

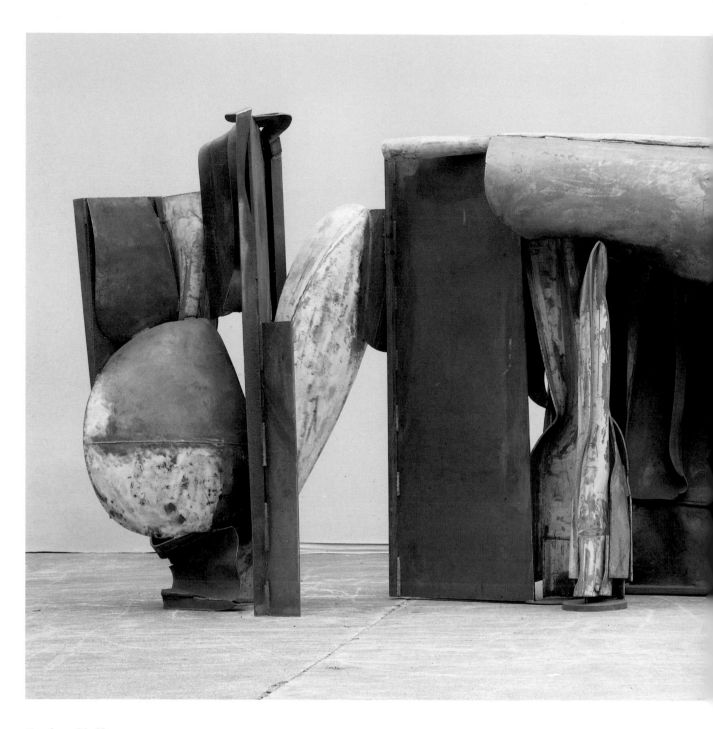

Xanadu 1986–88
Steel, waxed and varnished
240 × 622 × 162.5 cm (94½ × 245 × 64 in)
Private Collection USA, courtesy André Emmerich

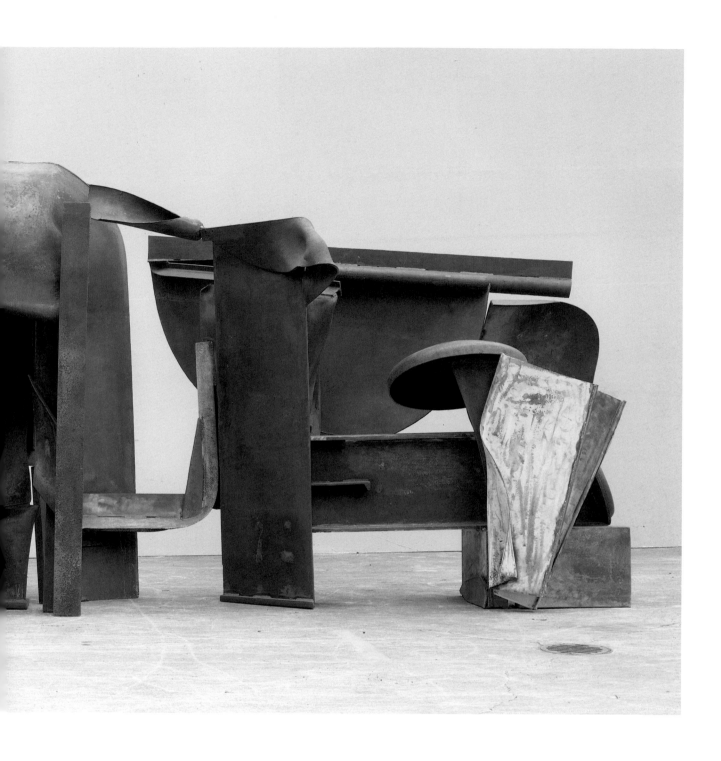

page 45
Octagon Tower – Tower of Discovery 1991
Steel, painted
671 × 554 × 554 cm (264 × 218 × 218 in)
Courtesy Annely Juda Fine Art

page 46
Octagon Tower – Tower of Discovery: construction

page 47
Octagon Tower – Tower of Discovery: interior views

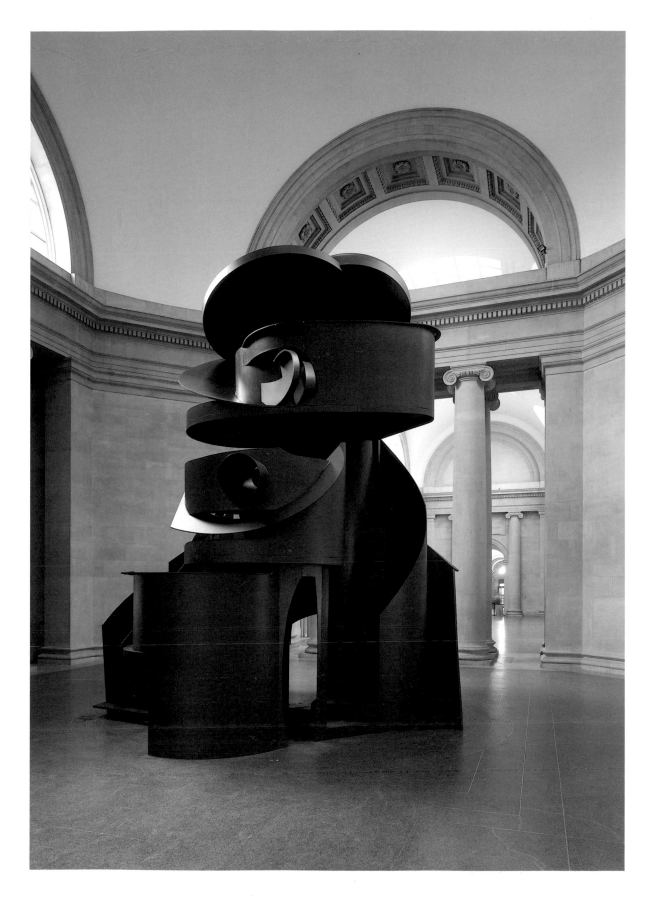

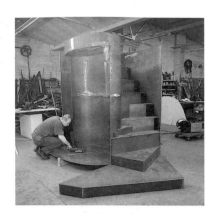
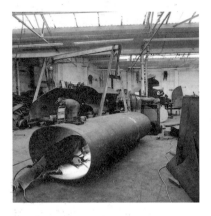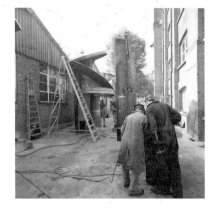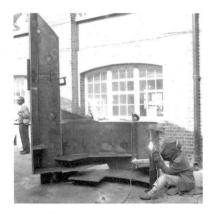
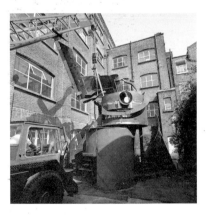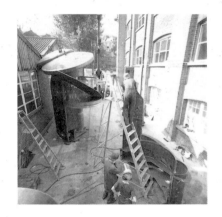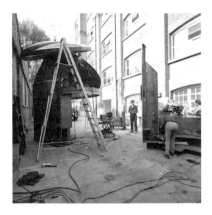
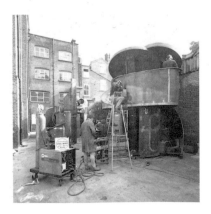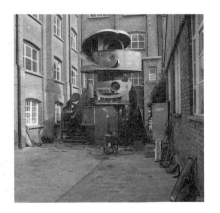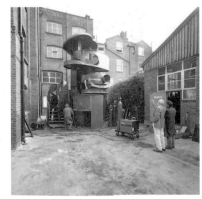

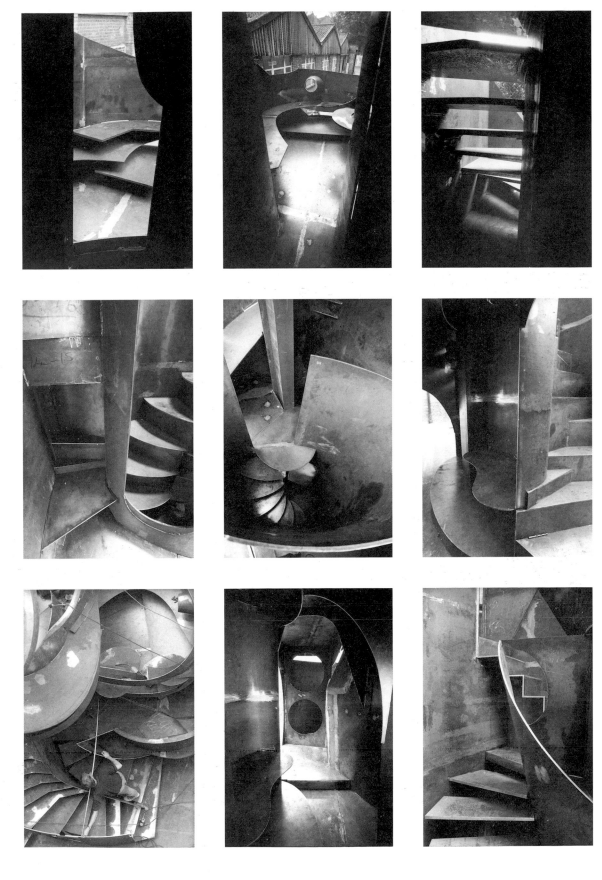

Select Chronology

1924
Born 8 March, New Malden, Surrey

1937–42
Attends Charterhouse School, Godalming, Surrey
During vacations works in studio of the sculptor Charles Wheeler

1942–4
Attends Christ's College, Cambridge; M.A. in engineering
During vacations attends Farnham School of Art

1944–6
Fleet Air Arm of Royal Navy

1946–7
Regent Street Polytechnic, London: studies sculpture under Geoffrey Deeley

1947–52
Royal Academy Schools, London

1948
Awarded two silver medals and one bronze medal from Royal Academy Schools for clay figure models, carving and composition

1949
Marries the painter Sheila Girling (two sons Timothy, 1951 and Paul, 1958)

1951–3
Works as part-time assistant to Henry Moore

1953–79
Teaches two days weekly at St Martin's School of Art, London

1954
Moves to Hampstead; models figurative sculpture in clay and plaster

1955
Included in group exhibition of sculpture at *New Painters and Painters-Sculptors*, Institute of Contemporary Arts, London

1956
First one-man exhibition: Galleria del Naviglio, Milan

1957
First one-man show in London: Gimpel Fils Gallery

1959
Wins sculpture prize at Paris Biennale
Tate Gallery purchases 'Woman Waking Up', 1955
Meets Clement Greenberg in London
Visits USA for the first time on Ford Foundation–English Speaking Union Grant; meets Kenneth Noland and David Smith, also Robert Motherwell, Helen Frankenthaler and others

1960
Returns to London; makes first abstract sculptures in steel including 'Twenty Four Hours', 1960 (Tate Gallery)
Visits Carnac, Brittany, studies the menhirs and dolmens

1961
First exhibits a steel sculpture 'The Horse', 1961 in *New London Situation*, Marlborough New London Gallery, London
First polychrome sculpture, 'Sculpture Seven', 1961

1963
One-man exhibition of abstract steel sculptures at Whitechapel Gallery, London

1963–5
Teaches at Bennington College, Bennington, Vermont
Renews contact with Noland and Smith

1964
First one-man exhibition in New York: André Emmerich Gallery

1965
Exhibits 'Early One Morning', 1962 (Tate Gallery) in *British Sculpture in the Sixties*, Tate Gallery, London

1966
Exhibits in *Five Young British Artists*, British Pavilion, Venice Biennale (with painters Richard Smith, Harold Cohen, Bernard Cohen and Robyn Denny)
Begins first table sculptures

1967
Retrospective exhibition at Rijksmuseum Kröller-Müller, Otterlo
Acquires stock of raw materials from estate of David Smith

1968
Exhibits 'Titan', 1964 in *Noland, Louis and Caro*, Metropolitan Museum of Art, New York

1969
Retrospective exhibition at Hayward Gallery, London
Appointed Commander of the Order of the British Empire
Exhibits, with John Hoyland, in British Section of Tenth São Paulo Biennale
Pat Cunningham becomes Caro's studio assistant

1970
Begins making unpainted steel sculptures

1971
Travels to Mexico, New Zealand, Australia and India

1972
Makes sculptures using roll end steel at Ripamonte factory, Veduggio, Brianza

1973
One-man exhibition at Norfolk and Norwich Triennial Festival, East Anglia
Museum of Modern Art, New York acquires 'Midday', 1960

1974
Works at York Steel Co., Toronto and makes large sculptures, assisted by sculptors James Wolfe and Willard Beopple.

1975
Retrospective exhibition at Museum of Modern Art, New York (which later travels to Walker Art Center, Minneapolis Museum of Fine Art, Houston and Museum of Fine Art, Boston)
Works in ceramic clay at workshop at Syracuse University, New York, organised by Margie Hughto
Begins making sculptures in welded bronze

1976
Presented with key to the City of New York by Mayor Abraham Beame

1977
Exhibition of table sculptures travels to Tel Aviv Museum and later tours Australia, New Zealand and Germany
Artist in residence at Emma Lake summer workshop, University of Saskatchewan

1978
Makes first 'writing pieces': calligraphic sculptures in steel
Executes commission for East Wing of the National Gallery in Washington, D.C.

1979
Receives Honorary Doctorates from East Anglia University and York University, Toronto
Made Honorary Member of American Academy and Institute of Arts and Letters, New York

1980
Makes first sculptures in lead and wood

1981
Makes wall pieces in handmade paper, with Ken Tyler in New York
Exhibits at Stadtische Galerie in Stadel, Frankfurt
Made Honorary Fellow, Christ's College, Cambridge

1982
Appointed Trustee of Tate Gallery, London
Initiates Triangle annual summer workshops for sculptors and painters at Pine Plains, New York; held annually thereafter
Joins Council of Slade School of Art

1984
One-man exhibition at Serpentine Gallery, London which travels to Copenhagen, Düsseldorf and Barcelona
Creates first sculpture with an architectural dimension: 'Child's Tower Room', Arts Council Commission, for *Four Rooms* exhibition at Liberty's, London

1985
Visits Greece for the first time
Exhibits at Noorkipings Kunstmuseum
Leads Sculptors' Workshop, Maastricht
Receives Doctor of Letters, Cambridge University
Jon Isherwood becomes Caro's US studio assistant at Ancram, New York

1986
Completes work on 'Scamander' and 'Rape of the Sabines', first of sculptures inspired by Greek pediments
Made Honorary Fellow, Royal College of Art

1987
Awarded knighthood, Queen's Birthday Honours
Executes 'After Olympia', his largest sculpture
Attends workshops in Berlin and Barcelona
Receives Honorary Degree, Surrey University

1988
Concludes investigation of pediment-inspired works with 'Xanadu'

1989
Exhibits at Walker Hill Art Center, Seoul
Sculpture workshop, Edmonton
Visits Korea and India
Receives Honorary Degree, Yale University

1990
Completes work on 'Night Movements', a single work in four separate units
Exhibits at Musée des Beaux Arts, Calais
Visits Japan and starts series of paper sculptures at Nagatani's workshop, Obama

1991
Two important sculptures involving the dialogue with architecture completed: 'Sea Music' for the quayside, Poole, Dorset and 'Octagon Tower – Tower of Discovery' for an exhibition of recent work at the Tate Gallery, London

Studio Assistants

Caro Studio

Patrick Cunningham
Michael Bolus
Sue Brown

Anthony Smee
Brenda Ward

Jon Isherwood
John Hock

Project Teams

After Olympia (1987)
David Gooding
Barbara Lander
Richard Lander
Carlo Mantegazza
Jane Clarke
Philip Medley
Christopher Williams
Guy Hardern
Garry Doherty

Xanadu (1986–88) and
Night Movements (1987–90)
Sean Cassidy
Simon Black

Octagon Tower – Tower of Discovery (1991)
Simon Black
Shapwick McDonnell
Derek Haworth
John Haworth
David Haworth
Sheila Vollmer
Elizabeth Wright
Julian Whiston
Dan Rappaport
Duncan Kerr
Neil Evans
Paul Smith
Georgio Sadotti
Stephen Thompson
Kirstie Reid
Gideon Peterson
Ian Dawson
Alastair Leslie
Susannah Oliver
Joe Oliver
Alistair Lambert
Sean Coogan
Richard Evans
Alec Vassiliardes
Patrick O'Sullivan
David Wilson

Credits

Transport
Rees Martin Art Service

Photography
Annely Juda Fine Art, Art Institute of
Chicago, Dennis Gilbert, John
Goldblatt, Carlos Granger, Kasmin
Ltd, Kim Lim, Guy Martin, John
Riddy, Phillip Sayer, David Scribner,
M. Tarnay, Tate Gallery Photographic
Department, Spyros Tsavdaroglou

Octagon Tower – Tower of Discovery

Steel bending
Benson – Sedgwick Engineering Ltd

Rolling angle parts
The Angle Ring Co Ltd

Grit blasting and spraying
Arnolds (Branbridges) Ltd, East
Peckham, Kent

The Friends of the Tate Gallery

Since their formation in 1958, the Friends of the Tate Gallery have helped to buy major works of art for the Tate Gallery Collection, from Stubbs to Hockney.

Members are entitled to immediate and unlimited free admission to Tate Gallery exhibitions with a guest, invitations to previews of Tate Gallery exhibitions, opportunities to visit the Gallery when closed to the public, a discount of 10 per cent in the Tate Gallery shop, special events, *Friends Events* and *Tate Preview* magazines mailed three times a year, free admission to exhibitions at Tate Gallery Liverpool, and use of the new Friends Room at the Tate Gallery which opens in November 1991.

Three categories of higher level memberships, Associate Fellow at £100, Deputy Fellow at £250, and Fellow at £500, entitle members to a range of extra benefits including guest cards, and invitations to exclusive special events.

The Friends of the Tate Gallery are supported by Tate & Lyle PLC.

Patrons

The Patrons of British Art support British painting and sculpture from the Elizabethan period through to the early twentieth century in the Tate Gallery's Collection.

They encourage knowledge and awareness of British art by providing an opportunity to study Britain's cultural heritage.

The Patrons of New Art support contemporary art in the Tate Gallery's Collection. They promote a lively and informed interest in contemporary art and are associated with the Turner Prize, one of the most prestigious awards for the visual arts.

Benefits for both groups include invitations to Tate Gallery receptions, an opportunity to sit on the Patrons' acquisitions committees, special events including visits to private and corporate collections and complimentary catalogues of Tate Gallery exhibitions.

Further details on the Friends and the Patrons may be obtained from:

Friends of the Tate Gallery
Tate Gallery
Millbank
London SW1P 4RG

Tel: 071-821 1313 or 071-834 2742

Tate Gallery, London – Sponsorships since 1988

Academy (Art & Design Magazine)	1988, Academy Forums
Henry Ansbacher & Co plc	1988, *Turner and the Human Figure* exhibition
AT&T	1988, *David Hockney: A Retrospective* exhibition
Barclays Bank plc	1991, *Constable* exhibition
British Gas plc	1989, Education study sheets
British Gas North Thames	1989, *Colour into Line: Turner and the Art of Engraving* exhibition
The British Land Company plc	1990, *Joseph Wright of Derby* exhibition
The British Petroleum Co plc	1989, *Paul Klee* exhibition 1990, *Tate Gallery: An Illustrated Companion* 1990–93, *New Displays*
British Steel plc	1989, *William Coldstream* exhibition
Carroll, Dempsey & Thirkell	1990, *Anish Kapoor* exhibition
Channel 4 Television	1991–93, The Turner Prize
Clifton Nurseries	1988–90, Sponsorship in kind
Daimler Benz	1991, *Max Ernst* exhibition
Debenham Tewson & Chinnocks	1990, Turner *Painting and Poetry* exhibition
Digital Equipment Co Ltd	1991–92, *From Turner's Studio* touring exhibition
Donaldsons	1988, *Hans Hofmann* exhibition
Drexel Burnham Lambert	1987–88, The Turner Prize
Drivers Jonas	1989, *Turner and Architecture* exhibition
Erco Lighting	1989, Sponsorship in kind
Gerald Metals Ltd	1988, Education and contemporary art exhibitions programme
Global Asset Management Ltd	1988, *Late Picasso* exhibition
Hepworth & Chadwick	1988, *Turner and Natural History* exhibition
KPMG Management Consulting	1991, *Anthony Caro: Sculpture towards Architecture* exhibition
Linklaters & Paines	1991, Japanese Guide to the Turner Bequest
Lin Pac Plastics	1989, Sponsorship in kind
Olympia & York	1990, Frameworkers Conference
PA Consulting Group	1988 *Turner's Wilson Sketchbook* publication 1989, Video projector

Plessey plc	1988, Sponsorship in kind
Pro Helvetia Foundation	1988, *Agasse* exhibition
Reed International plc	1990, *On Classic Ground* exhibition
SRU Ltd	1989, Market research consultancy
Swissair	1988, *Agasse* exhibition
Tate & Lyle PLC	1991–93, Friends relaunch marketing programme
UBS Philips & Drew	1988, *Turner at Petworth* publication
Ulster Television	1989, *F.E. McWilliam* exhibition
Volkswagen	1989–92, Turner Scholarship
Westminster City Council	1989, Trees project
	1989, *Tate Gallery: An Illustrated Companion* (New Display guidebook)

Corporate Membership Programme

Partners
Barclays Bank plc
The British Petroleum Co plc
Manpower UK
THORN EMI

Associates
Debenham, Tewson & Chinnocks
Ernst & Young
Global Asset Management
Lazard Brothers & Co Ltd
Tate & Lyle PLC
Unilever